CAT PEOPLE

30 postcards

DARLING & COMPANY SEATTLE

MM

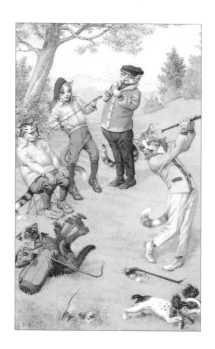

THE CATS

THE CATS on these postcards were created from the 1940s through the 1960s by an artist named Hartung. We know little about him, not even a first name, but his signature appears on most of the cards as a heart with a tongue-like loop in its center. They were originally published in Zurich, Switzerland by the Max Kunzli Company. No one knows how many designs were made, but more than two hundred designs have been counted.

The use of animals to satirize human conduct begins with Aesop and a collection of Indian animal fables, The Panchatantra, both of which date from the sixth century BC. The Hartung postcards, like the fables, allow us to see ourselves at a distance, to laugh at our follies and pretensions without very much cruelty or remorse. They also present a detailed picture of an era.

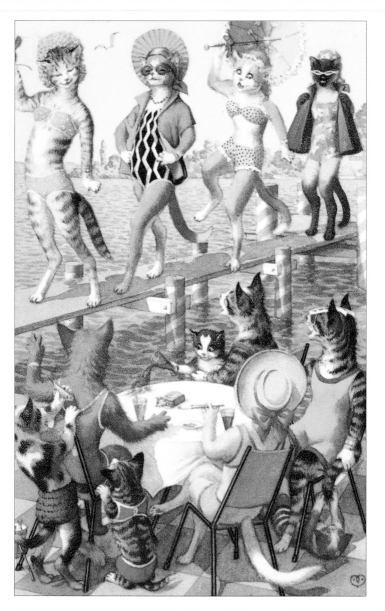

POST
CARD

DARLING & COMPANY POSTCARD

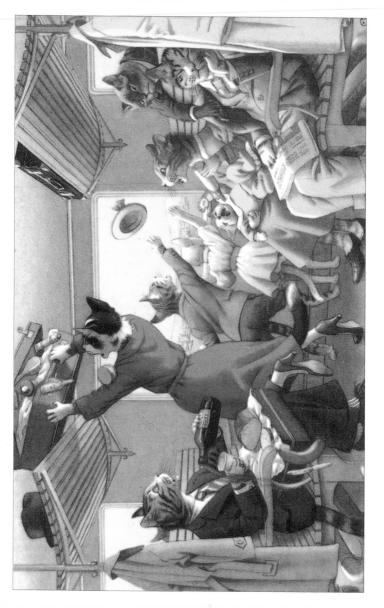

POST
CARD

DARLING & COMPANY **POSTCARD**

STAMP HERE

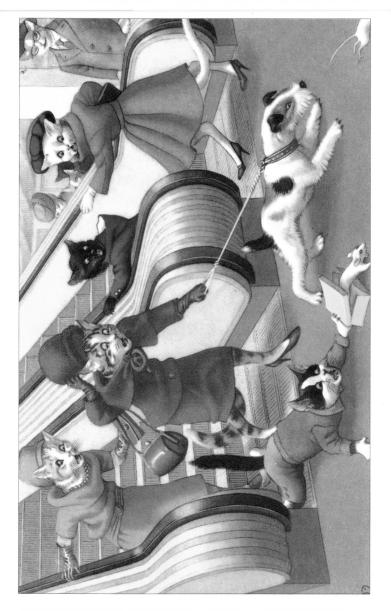

POST
CARD

DARLING & COMPANY · POSTCARD

STAMP HERE

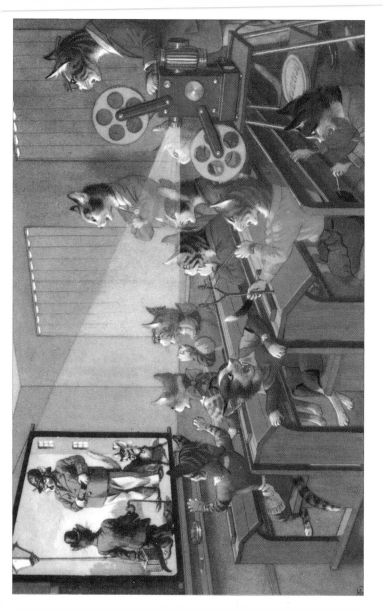

POST CARD

DARLING & COMPANY 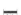 POSTCARD ←

AMP **HERE**

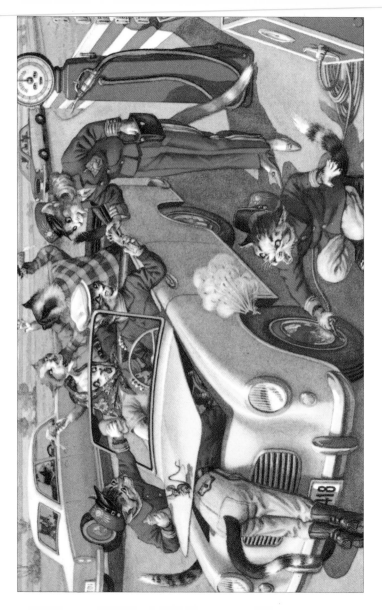

POST
CARD

DARLING & COMPANY POSTCARD

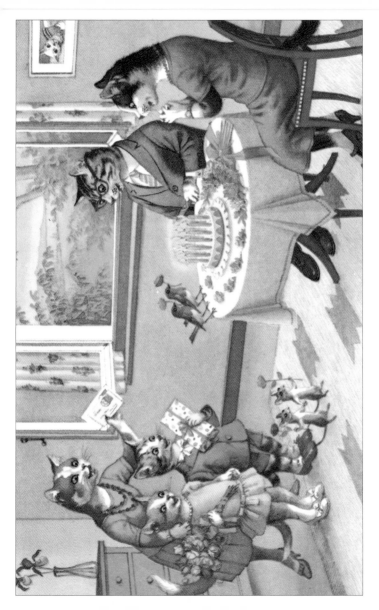

POST
CARD

DARLING & COMPANY 🛡️ POSTCARD ⟵

STAMP HERE

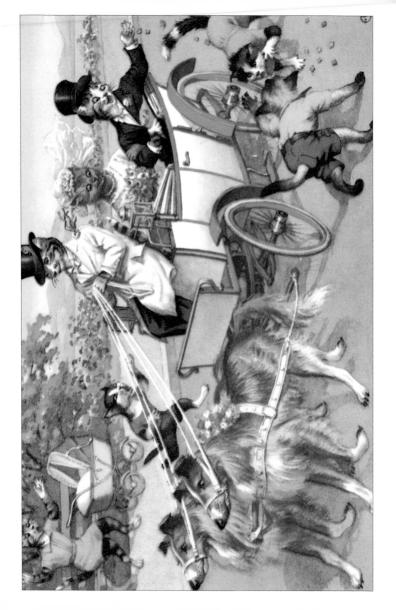

POST
CARD

STAMP HERE

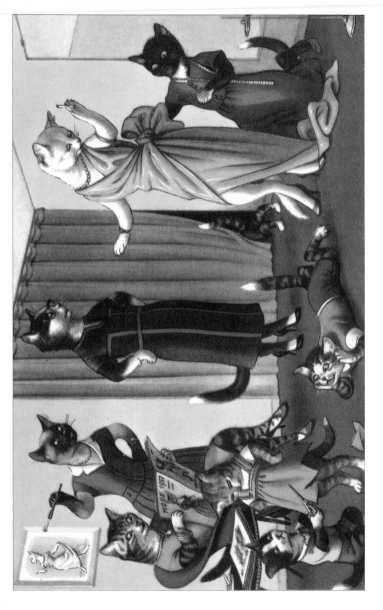

ILLUSTRATED BY **HARTUNG**

POST
CARD

DARLING & COMPANY POSTCARD ←

STAMP HERE

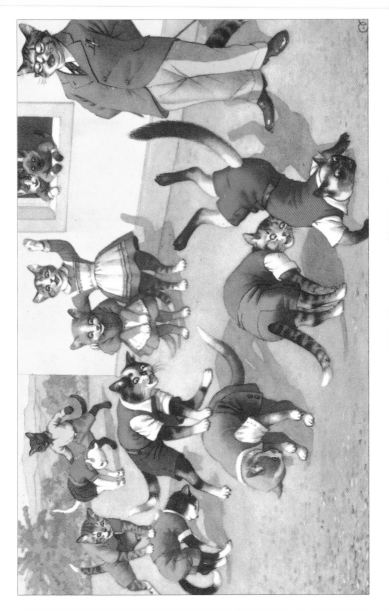

POST
CARD

DARLING & COMPANY POSTCARD

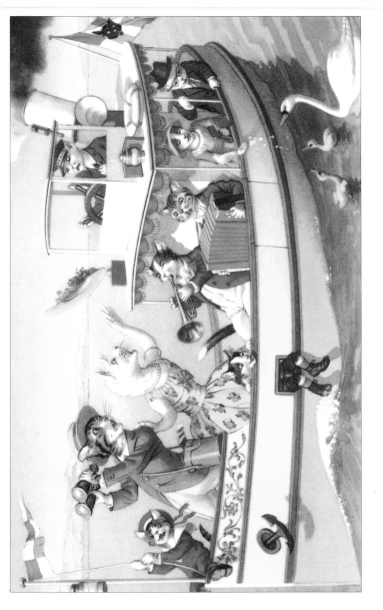

POST
CARD

DARLING & COMPANY ——————— POSTCARD ◀

STAMP **HERE**

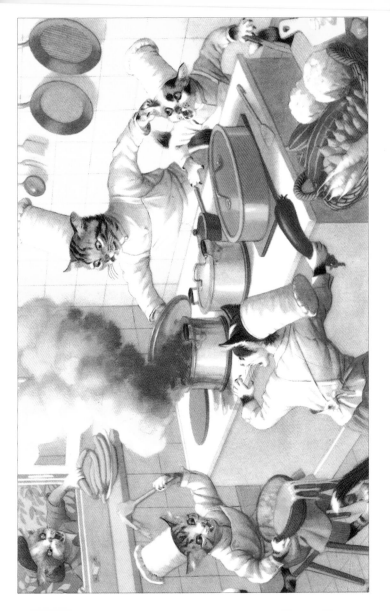

POST
CARD

DARLING & COMPANY POSTCARD

STAMP HERE

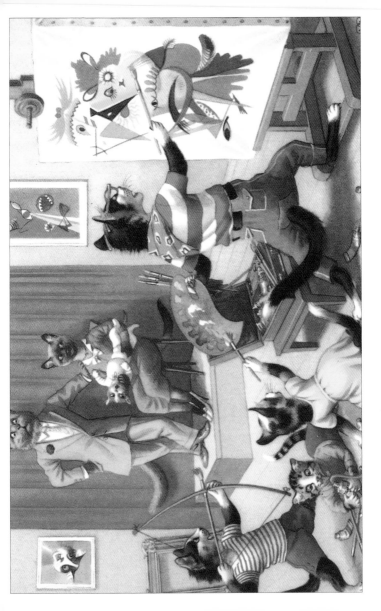

POST CARD

DARLING & COMPANY POSTCARD

STAMP 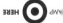 HERE

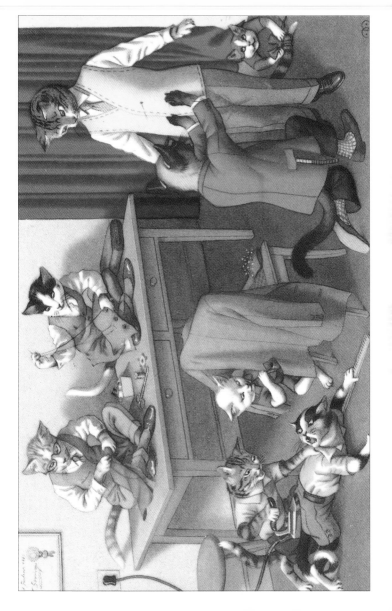

POST CARD

DARLING & COMPANY POSTCARD

STAMP HERE

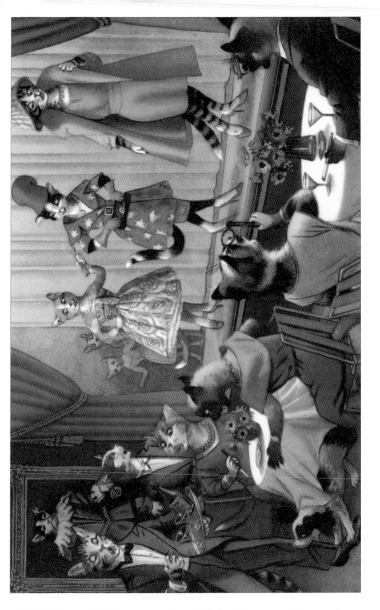

POST
CARD

DARLING & COMPANY · POSTCARD

STAMP HERE

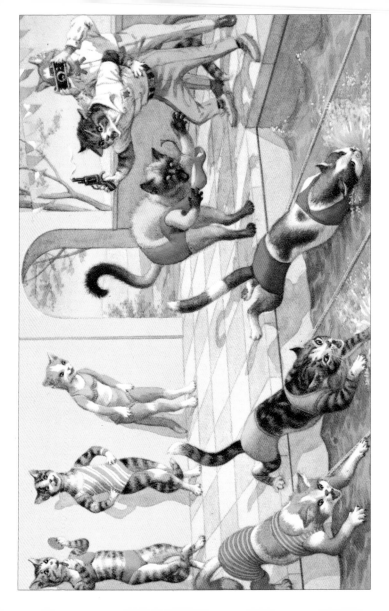

POST
CARD

DARLING & COMPANY POSTCARD

STAMP HERE

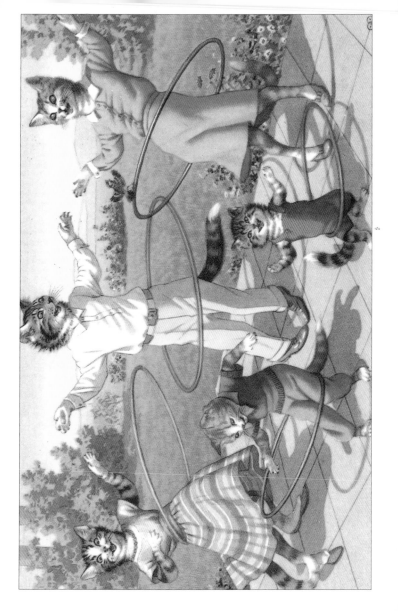

POST
CARD

DARLING & COMPANY POSTCARD

STAMP HERE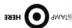

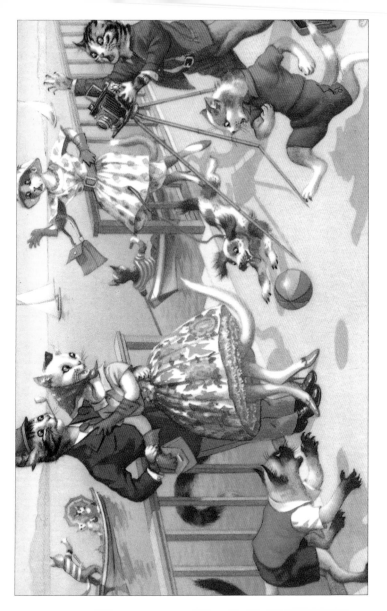

POST
CARD

DARLING & COMPANY — POSTCARD

STAMP HERE

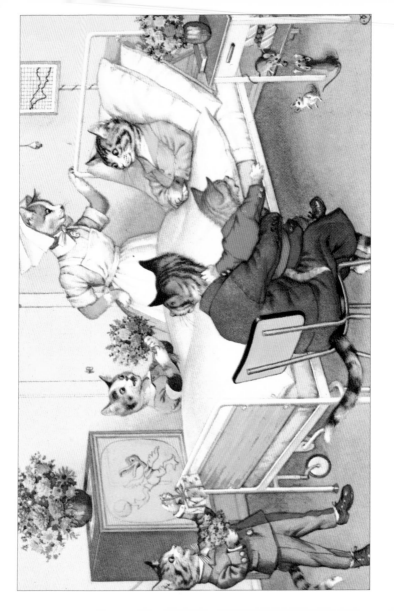

POST
CARD

DARLING & COMPANY 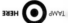 POSTCARD

STAMP HERE

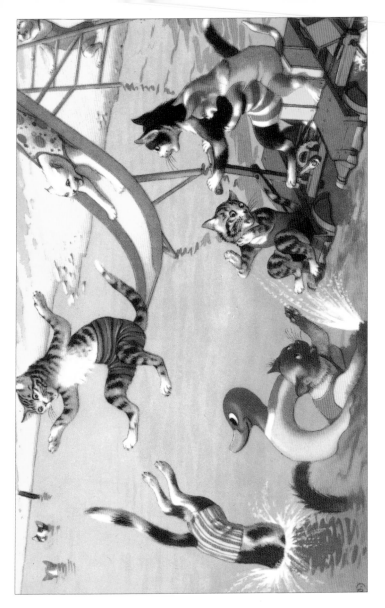

POST
CARD

DARLING & COMPANY POSTCARD

STAMP HERE

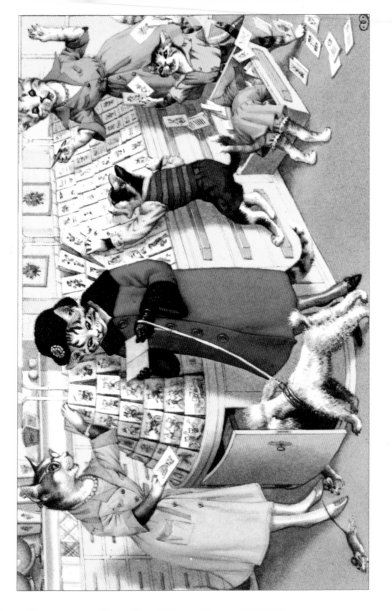

POST
CARD

STAMP HERE

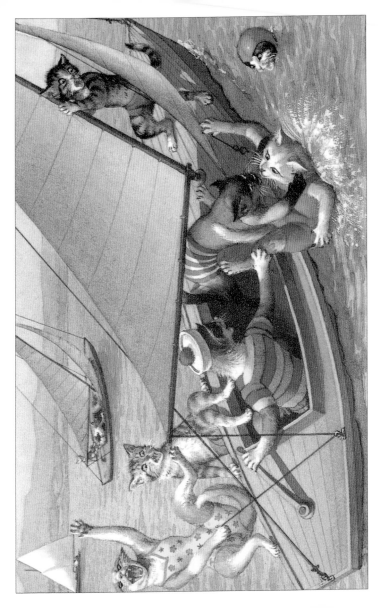

POST
CARD

DARLING & COMPANY POSTCARD

STAMP HERE

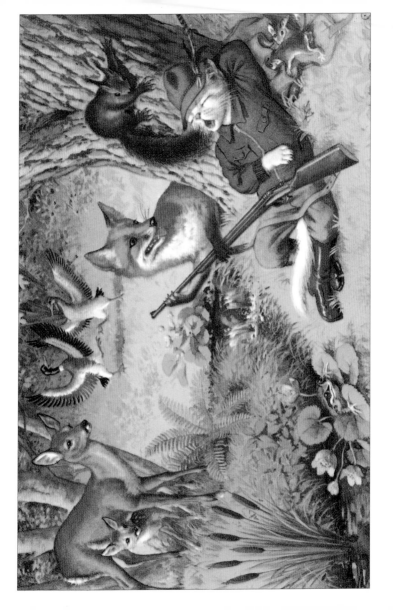

ILLUSTRATED BY **HARTUNG**

POST
CARD

DARLING & COMPANY **POSTCARD**

STAMP
HERE

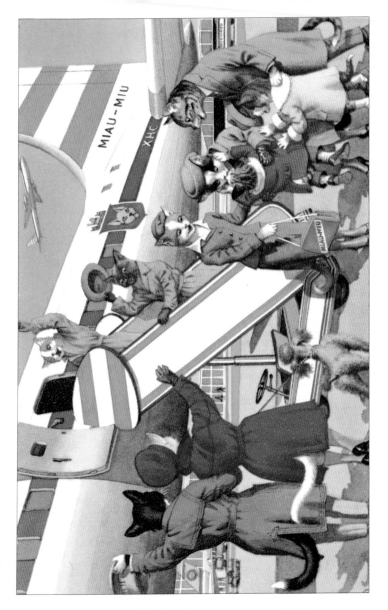

POST
CARD

DARLING & COMPANY POSTCARD

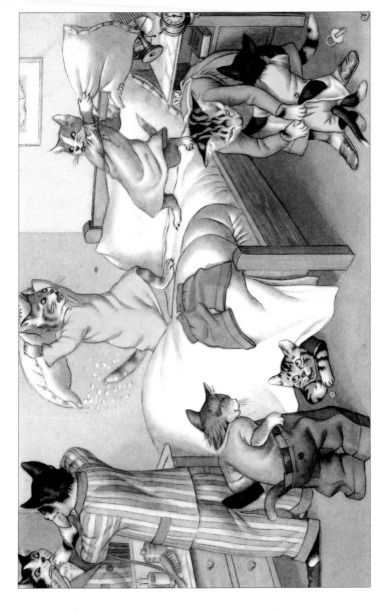

POST
CARD

DARLING & COMPANY POSTCARD

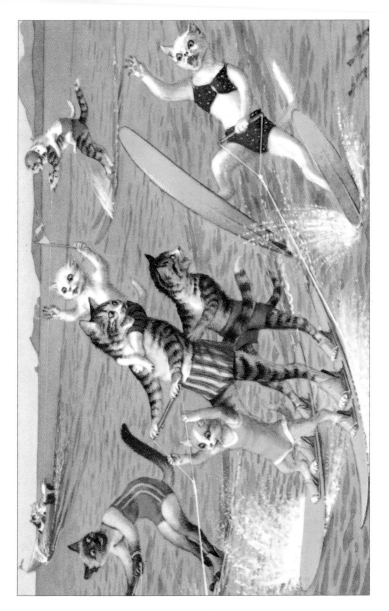

POST
CARD

DARLING & COMPANY 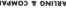 POSTCARD

STAMP HERE

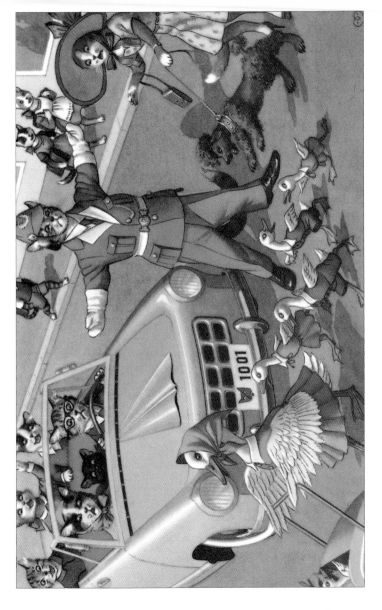

POST
CARD

DARLING & COMPANY **POSTCARD**

STAMP 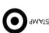 HERE

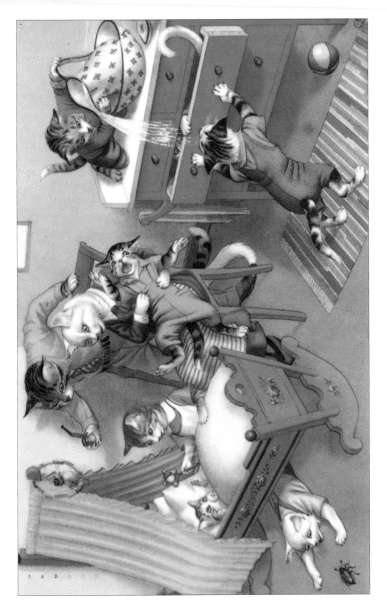

POST
CARD

DARLING & COMPANY POSTCARD

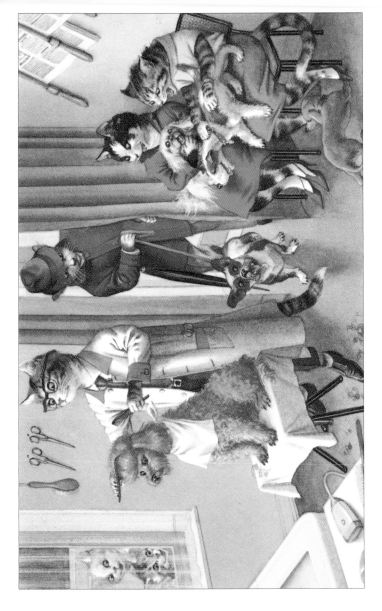

POST
CARD

DARLING & COMPANY POSTCARD

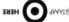

STAMP HERE

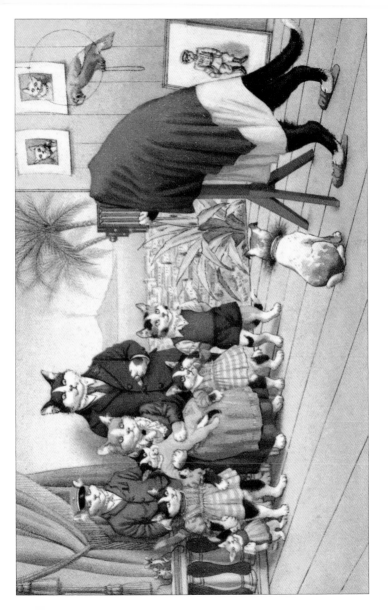

POST
CARD

DARLING & COMPANY POSTCARD

STAMP HERE

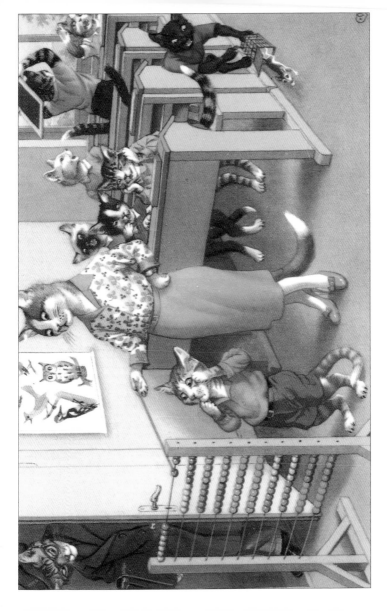

POST
CARD

DARLING & COMPANY POSTCARD

STAMP HERE